Y0-CAR-275

CONTEMPORARY PRAYERS TO

[whatever works]

HANNAH BURR

CONTENTS

rest

My body feels *run over*
right now.

, help me to
breathe in and circulate your pure
bright presence within me.
Please burn off all this stagnance.
Remind me what it's like to be
walking around feeling healthy.

, I am overwhelmed and exhausted. Please restore my mental and emotional peace.

, please help me to
open to the idea that you're
crazy about me, that you have
a beautiful plan for me, and
that there's nothing for me
to force.

, please be with me
all through the night tonight.
Hold me. Help me rest.

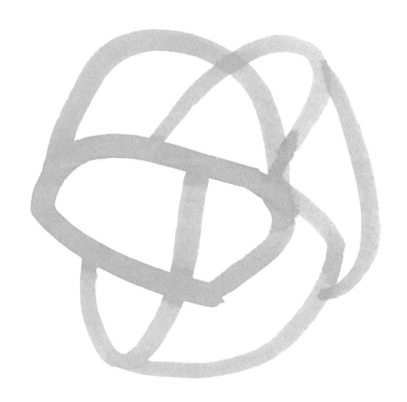

This hurts, 　　　.
Please carry me through.

up close with

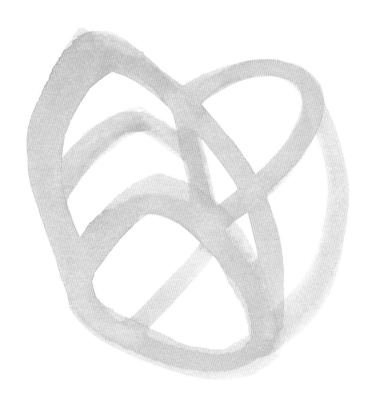

Really ? *Really?*
Do you see how hard I'm working
here? Can you give me a fucking
break please?

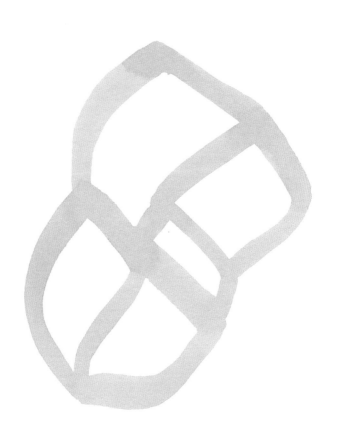

, I want to know
your love for me, first
hand. I'll be on
the lookout today.

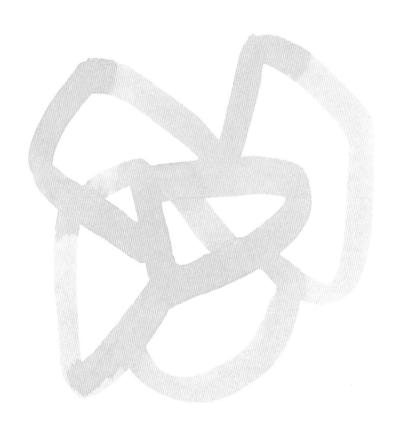

I'm pissed at you, _____!
You let me down! I want to
trust you and it's hard. Help me
not to shut down. Show me
the way through.

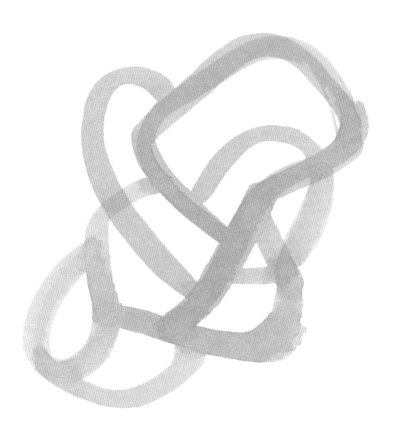

, I want to be in your company, to notice you, even to be surprised by how you truly get me.

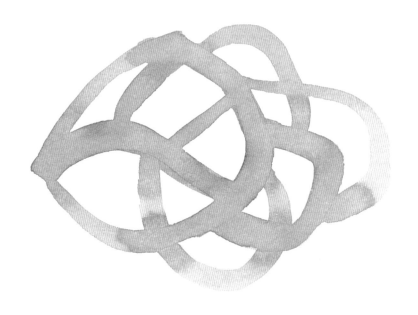

Hey !
I **can't handle** what you think I can handle! It feels impossible. This is all I've got for now.

stuck

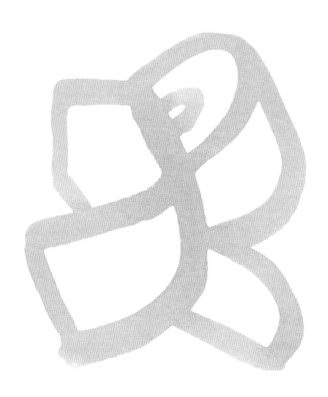

I'm obsessing!
My thoughts are
on a loop.
, please quiet
my mind.

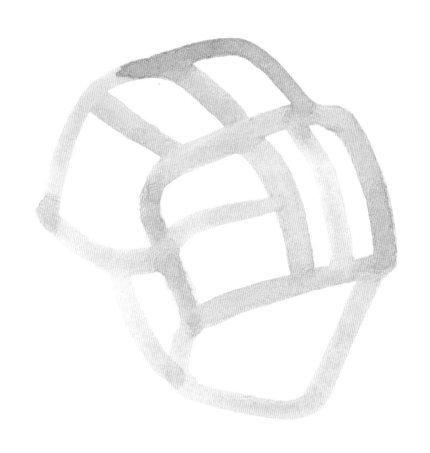

, can you help
me slow down or stop
for a bit?

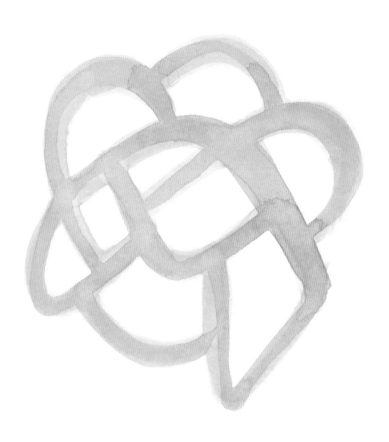

, I'm confused and frustrated.
Please show me the way
out of this thicket.

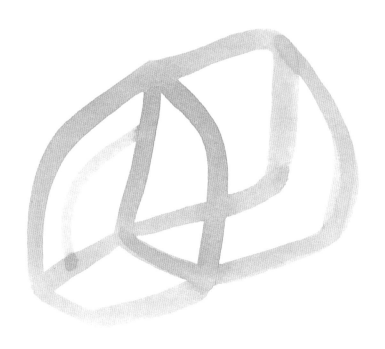

, I have a tendency to overdo it in the ████████ department, and I need your help.

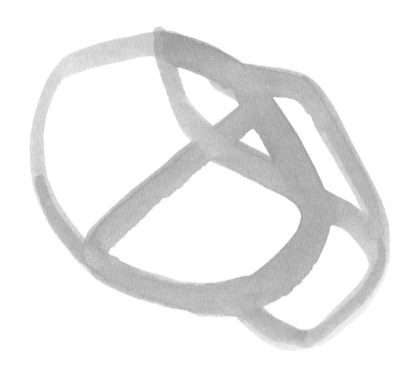

I'm out of synch.
, please lead me
- gently if possible -
back to myself.

conflict

, please show me where
I may be at fault in this situation.
Indicate if action is needed on
my part. If so, come with me ok?
Better yet, go before me, so
you're already there when I
get there. Thank you.

, can you show
me how I am like ▓▓▓▓▓ ?
I want to be done with this
drama! Remind me of how
we're not so different, ok?

, please take
this relationship and make
it what you want it to be,
and show me the truth.

, help me to be easier
on myself and others. Please open
my mind and lower my shoulders.

_____ , help me to see myself in _____ , to shake off any misunderstandings, distortions or magnifications that may be lurking within me.

fear and loathing

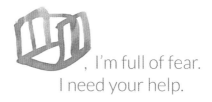, I'm full of fear.
I need your help.

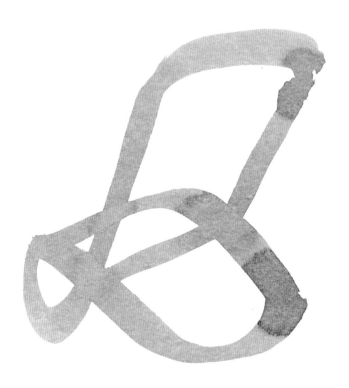

God, can you help me
see the silver lining here?

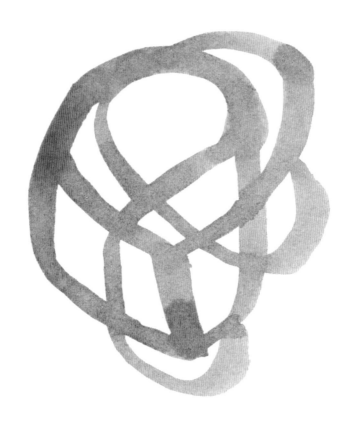

, all I've
got for you right now is
this wretched feeling of
Please accept my .
humble offering.

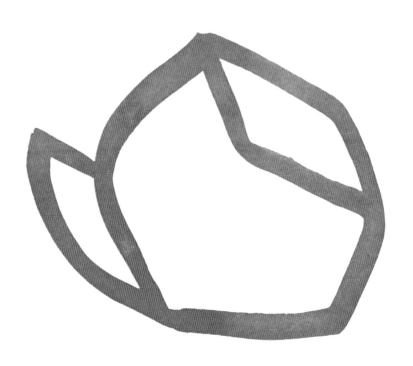

, I'm lost, I'm scared.
Please be with me.

, please be with me.

letting go

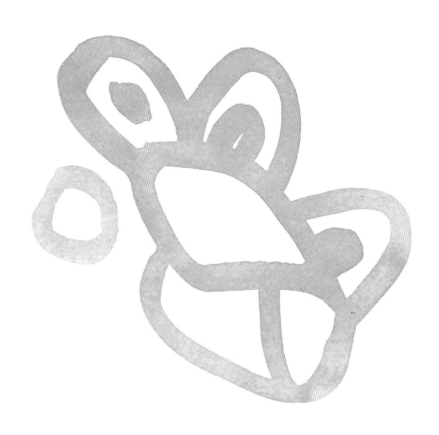

, help me to
keep my mitts off this thing,
and to let this situation
unfold on its own.

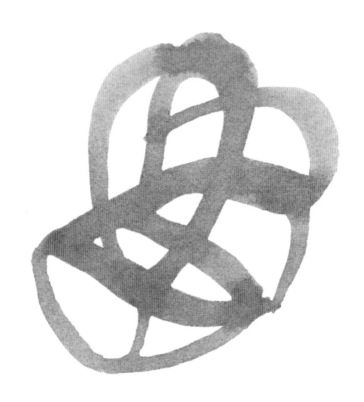

Inspire this creative
effort,

Please make this
easier than I imagined
and make it fun!

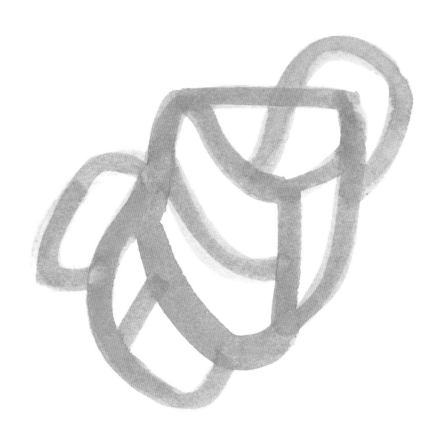

I'm all out of ideas here.
It's all yours,

I'm putting it down. I surrender.

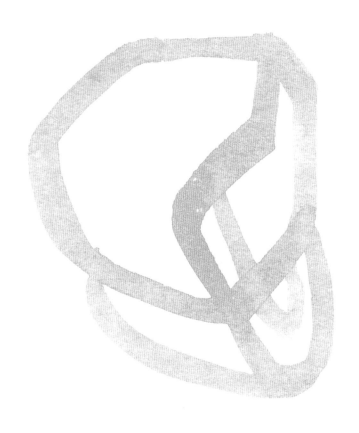

, if it's time
to let this go, please make it clear and
give me strength. If it is not yet time,
I ask you for patience, and to
show me how to be.

I want to trust you,

Show me how to
soften and to just be along
for the ride on this one.

making choices

Hey ❀ , what's
the next right action?
I'm muddled and not
deciding right.

, please show
me what to eat right now.

What next ?

, what are my
marching orders for today?

Help me to stay within
my budget on this
grocery trip, ok

?

being with oneself

, help me
to be grounded and connected
to myself right now. Please
remove whatever
blocks that connection.

, help me to
get out of my own way
today.

.

, help me to
trust and know that
I am welcome on this planet,
scales and all, and squarely
on my path, even now.

Help me to be nice to myself,
like a good friend to myself.

Can you help me to
 relax in my own skin, ?
Please remind me that
 I'm just fine, OK? I want to
 feel at home in here.

appreciation

Thank you for
being the tree in my yard,
and the chair that I'm sitting in.

, I have many things to thank you for in the day, among them ,

, and , and ,

and , and , and .

107

, thank you
for food, shelter, and matching
socks. For my breathing,
my senses and .

, thank you for this fine, fine day! I felt you with me in the following situations:

.

Thank you , for your careful attention to detail in my life. For what you're quietly making possible within it.

for others

, please show me
how to be a better friend.

_____, I leave _____ in your care. Help me to know that you're in _____ 's life, that _____ is taken care of, and in exactly the right place.

_____ , please be with _____ . Help _____ to heal, to feel peace, moments of levity, and even humor in the day.

_____, when I am with _____ later on, help me to just be, as you would have me be. I would love to be relaxed and present, and myself.

Give me the words, .
Show me what to say
and how to be.

ABOUT THE AUTHOR

Hannah Burr is an artist who lives in Boston. She uses these and other prayers to relax and enjoy seismic shifts in her life. They've helped her remember, as she forgets repeatedly, that there are larger forces at work, gravity for example, of which she is a part. These prayers help her accept and tap into whatever that is.

This book is one of her art projects. To learn more about the ink drawings and her other projects, visit hannahburr.com, whateverworksbook.com or her blog, goodbonfire.com.

Original book design by Hannah Burr
Cover design by Leila Simon Hayes and Hannah Burr

Text © 2013 Hannah Burr
Artwork © 2013 Hannah Burr

Special thanks to Stephanie Chace for the prayer
on p.49. All other prayers and artwork by Hannah Burr
and .

Many thanks to each and every last backer on
Kickstarter. Also, to Jody Burr, Alex Emerson, Anne
Emerson, Kyle Freeman, Andrew Innes, Genia Patestides,
Sally Ryder Brady, Leila Simon Hayes, and Riley Solter.

Reprint: 2014. Originally printed: 2013.

ISBN 978-0-9889166-0-9

whateverworksbook.com

Printed in China